© Crown copyright 1972
Second impression 1984

ISBN 0 11 290135 2

Front cover: Miraculous Draught of Fishes
Back cover: detail from the Miraculous Draught of Fishes

Photography: Sir Geoffrey Shakerley

HER MAJESTY'S STATIONERY OFFICE

Government Bookshops

49 High Holborn, London WC1V 6HB
13a Castle Street, Edinburgh EH2 3AR
Brazennose Street, Manchester M60 8AS
Southey House, Wine Street, Bristol BS1 2BQ
258 Broad Street, Birmingham B1 2HE
80 Chichester Street, Belfast BT1 4JY

Government publications are also available through booksellers

The full range of Museum publications is displayed and sold at the
Victoria and Albert Museum

Obtainable in the United States of America and Canada from
Kraus Thomson Organisation Ltd.
Millwood
New York 10546

Printed in the UK for HMSO
Dd 736263 C90

Introduction

The seven tapestry cartoons by Raphael form part of the royal collection but have, since 1865, been on loan at the Victoria and Albert Museum. They are among the greatest works of art to have survived from the period of the High Renaissance. Their intrinsic qualities are matched both by their subsequent influence on the history of art and by the extent to which they have moulded the mental image of the New Testament story for generation after generation.

The history of the cartoons

The cartoons (pls. 1–7) are part of a set of ten commissioned by Pope Leo X for tapestries which were designed to complete the decoration of the Sistine Chapel in the Vatican and which are now exhibited in the Vatican Gallery. The cartoons represent subjects drawn from the lives of St Peter and St Paul: *The Miraculous Draught of Fishes* (Luke v. 3–10). *Christ's Charge to St Peter* (John xxi. 15–17), *The Healing of the Lame Man* (Acts iii. 1–11), *The Death of Ananias* (Acts v. 1–6), *The Blinding of Elymas* (Acts xiii. 6–12), *The Sacrifice at Lystra* (Acts xiv. 8–18), and *St Paul Preaching at Athens* (Acts xvii. 15–34). The three cartoons which have been lost are those for the tapestries of *The Stoning of St Stephen* (Acts vii. 55–60), *The Conversion of Saul* (Acts ix. 1–7), and *St Paul in Prison* (Acts xvi. 23–6).

Records of only two payments for the cartoons still survive. One is from 15 June 1515 (300 Ducats); and the other from 20 December 1516 (134 Ducats). By this time some of the cartoon designs had already been engraved, and at least the first of the cartoons themselves had probably been sent north to the Brussels weaver, Pieter van Aelst, *Tapissier du Roi* to the King of Spain and later 'Court Worker' to the Emperor Charles V. Then, on Saint Stephen's Day, 26 December 1519, Paris de Grassis, the Papal Master of Ceremonies, records that the Pope 'ordered his new, most beautiful, and precious pieces of tapestry to be hung, at the sight of which the whole chapel was stunned, and it was the universal judgement that there is nothing more beautiful in the world and the value of each is two thousand Ducats in gold.' In fact only seven of the set had actually arrived, since on the very next day, Marc Antonio Michiel, the Venetian diarist and recorder of works of art, wrote with similar enthusiasm that 'This Christmas the Pope showed in the chapel 7 pieces of tapestry since the eighth was not furnished, made in the north, which were adjudged the most beautiful thing of this sort which had ever been made up to our own day . . . The designs for these tapestries for the Pope were made by Raphael of Urbino, an excellent painter, who received from the Pope one hundred Ducats each, and the silk and gold in them are most abundant, and the weaving cost 1,500 Ducats each, so that they cost in all, as the Pope himself said, 1,600 Ducats apiece, though it was estimated and spread about that they were worth 2,000.'

From this it appears that Raphael was paid 1,000 Ducats in all, as compared with 1,200 Ducats paid for the more or less contemporary frescoes in the Stanza dell' Incendio in the Vatican.

On arrival in Brussels the cartoons were, according to common practice, cut into strips to facilitate their use. Nevertheless, they almost immediately came, in Italy at least, to be regarded as works of art in their own right. As early as 1521 Michiel saw the now missing *Conversion of Saul* in the collection of Cardinal Domenico Grimani in Venice.

It seems that no further sets of tapestries were woven from the cartoons while they were in van Aelst's workshop. The designs, including presumably a copy of the *Conversion of Saul*, appear to have been in the hands of Jan van Tiegen, another Brussels weaver, before the end of the '20s. Several sets of nine tapestries, excluding the narrow *St Paul in Prison*, were woven during the succeeding period. One of the finest, seemingly, was ordered by Francis I of France, who bought the first three pieces in 1534. It was burnt in 1797 to recover the gold from its gold thread. Another set, probably commissioned for Henry VIII was destroyed in Berlin in the Second

World War. A third set, commissioned by Margaret of Austria before 1528, and now in Mantua, came into the possession of Ercole Gonzaga, whose arms were added to it, whilst a fourth, also possibly commissioned by Margaret of Austria, survives in Madrid. Later, many further sets of nine were made by other weavers in Brussels and in Paris, and these include a set woven by Jan Raes and Jacques Geubels of Brussels, which is now in Hampton Court.

The cartoons were still in Brussels in 1573, but by 1623 they had arrived in Italy. On 28 March of that year Charles, Prince of Wales, wrote from Madrid asking for money to be set aside for 'certaine patterns to be brought out of Italy, and sent to us into England for the making thereby a Suite of Tapestry. wch drawings (as we remember) are to cost neir uppon the poynt of Seaven hundred pounds.'

On 28 June 1623 action was taken on an undated letter from Sir Francis Crane, the manager of the Mortlake tapestry works formed by James I in 1619, reporting that he had been ordered by Prince Charles, before his journey, 'to send to Genua for certayne drawings of Raphaell of Urbin, which were desseignes for tapestries made for Pope Leo the Xth, and for which there is 300.l to be payed, besides their charge of bringing home. In fact only the existing seven cartoons entered the Royal Collections, as is confirmed by van der Doort's Inventory of 1639. In it he lists a 'flatt Case wherein some 2 Cartouns of Raphael Urbins for hangings to be made by' and five others are said to have been sent to Francis Cleyn at Mortlake 'to make hangings by vor his M Sarfiss.'

Cleyn had copies of the cartoons made and also commissioned new designs for the borders. Quite apart from the fact that the drawings for them had evidently been lost by this date, the original symbolic side borders had been especially designed to fit the situation in the Sistine Chapel, and the lower borders, half of them being illustrations of the life of Leo X, would have been even more unsuitable for re-use. More than a dozen of the resulting Mortlake sets of the *Acts of the Apostles* can still be traced. The finest of them, bearing the royal arms of England, was bought for Cardinal Mazarin at the sale of Charles I's collection and at Mazarin's death was bequeathed to the French Crown. It is now in the Garde-Meuble in Paris. Two other sets 'of English making' were also in the possession of Louis XIV. There is also a fine set in Dresden. Amongst those preserved in Britain, two sets are owned by the Duke of Buccleuch and there are others at Forde Abbey, Belvoir, Woburn, and Chatsworth. A Mortlake version of the *Miraculous Draught of Fishes* is at present on loan to this Museum and hangs opposite Raphael's cartoon.

When Charles I's possessions were valued, after his death, by Trustees appointed by the Commonwealth, the cartoons, which were then in 'large Deal Boxes in the Banquetting House at White-hall, some of them being in four and others in five pieces', were valued at their purchase price of £300. They were, however, later included among the goods reserved from sale for the service of the state. At the Restoration the cartoons returned to the possession of Charles II, and in the latter part of the century an unsuccessful attempt was made to buy them for the Gobelins factory, in which Louis XIV was interested. In the mid '60s, the French School in Rome had, indeed, been ordered to make oil copies of the Vatican Tapestries themselves. These were used both by the tapestry factory at Beauvais and by the Gobelins in Paris. At Mortlake the resumption of production was short-lived and the weavers had already dispersed some years before the formal closure in 1703.

Once the cartoons were no longer needed for tapestry production, the strips into which they had been cut on their first arrival in Brussels were pasted together and the cartoons were returned, as far as intervening wear and tear allowed, to the form in which they had left Raphael's studio. Although a gallery for their display was not part of Sir Christopher Wren's brief when, under William III, he set about the rebuilding of Hampton Court, space was soon set aside for them. In an estimate of April 1699, Sir Christopher in fact refers to the gallery 'to be fitted for the cartoones with wanscot on the window side and below the pictures and between them, and with wanscot behind them to preserve them from the walls.' Five months later, in September, William Talman noted that 'the gallery for the cartoones of Raphael is so forward that I shall fix up the pictures in a week.' His very form of words reflects the final stage in the actual process of transition from cartoon or working drawing into work of art or picture.

The cartoons remained at Hampton Court until in 1763 they were moved to the 'Saloon' at Buckingham House, where they remained until they were transferred to Windsor Castle in 1787. At Windsor four of them were hung in the King's Presence Chamber and three in the Queen's Presence Chamber. Then, in 1804, George III ordered their return to Hampton Court and subsequently, in 1816, 1817, 1818 and 1819, the Prince Regent allowed individual pieces to be lent to the British Institution. Later in the century, the Prince Consort became personally engaged in the study of Raphael and his works, and after his death in 1861 his eldest daughter, then Crown Princess of Prussia, proposed that the cartoons should be transferred on loan to what was then the

[1] I am indebted to Dr John Shearman for information on a number of points relating to the history of the cartoons.

South Kensington Museum. The loan was approved by Queen Victoria in 1865, and since that date the cartoons have, by permission of successive Sovereigns, remained on public view in this Museum.[1]

State and technique

Considering their fragility and the rough treatment to which, as working drawings, they were inevitably exposed for the first two hundred years of their history, the cartoons are remarkably well preserved.

Each cartoon is made up of a more or less regular mosaic of about 180 to 205 overlapping pieces of paper, the full sheets measuring c. 42 cm. by 28.5 cm. Occasionally, where damage has occurred, successive repairs have resulted in areas which are six or seven layers thick, but for the most part there is only a single thickness. The 1–4 cm. overlap is particularly clearly visible as a pale lattice pattern on the upper part of the figure of St John in *The Death of Ananias* (pl. 33), where the doubled thickness of the paper seems to have given some protection to a particularly fugitive pigment which has otherwise almost completely faded away. The late seventeenth century canvas backing, which, in six of the cartoons, was given added canvas support in 1935, has never been disturbed. The extensive wrinkling of the paper surface is a result of the expansion which took place when the paper absorbed moisture from the aqueous adhesive used by the painter Henry Cooke to attach it to the original canvas support.

Apart from a few holes and tears, and many large and small abrasions of the original paint surface, the major damages tend, somewhat naturally, to fall along the edges of the five to eight vertical strips into which each cartoon was cut by the weavers. Some repainting and restoration must, therefore, have taken place on a number of occasions from the sixteenth century onwards. In 1966 the cartoons were gently cleaned by rolling finely powdered gum rubber over the surface with cotton wool pads in order to absorb the accumulated dust and grime without disturbing the paint film in any way. It then was found that the original painting was carried out in a limited range of pigments in an animal glue medium. The nine pigments used were: white lead, carbon black, earth colours (iron oxide), azurite, malachite, massicot (yellow lead monoxide), red lead, vermilion, and red and pink lake. Though most of the colours have stood up reasonably well, the red lake, the only vegetable dye used, has almost completely faded. In *The Miraculous Draught of Fishes* (pl. 1), for example, this explains the pink reflection of what is now Christ's white garment. As can be seen in the Vatican tapestry, and in the Mortlake version hanging on the opposite wall, this was once a rich red robe.

For the most part no attempt was made in the 1966 cleaning to remove the old retouchings carried out by Henry Cooke and others. A notable exception was, however, a large and badly discoloured area in the sky and water to the right of this same figure of Christ, where the removal of the overpaint brought to view a flight of birds and some swans disporting themselves on the waters. On the other hand, the major areas of unsightly staining or of pigment loss, such as the one along the vertical join which so disturbingly cut in half the figure of the apostle in blue on the far right of *Christ's Charge to St Peter* (pl. 2), were made good by retouching with dry pastel. All the colours used in this way were pure permanent pigment, without any gum or resinous medium, and can easily be removed at any time without disturbing either the fibres of the paper or original paint. The restoration was completed by the addition of new metal mountings, the fitting of air filters to the rear of each frame, and the provision of movable louvres below the skylights, automatically operated by photo-electric cells, in order to control the intensity of light within the Gallery and thereby minimize further fading.

As soon as the cartoons are examined in detail, a number of variations in hand are clearly visible. The distinction between the heads of the apostles in *The Death of Ananias* (pl. 4) and those of Ananias (pl. 34) and of others of the foreground figures is an obvious case in point. It should not be assumed that such variations are always the result of repainting. When work was going ahead on the cartoons, Raphael was at the height of his career. He was carrying out commissions for easel paintings, frescoes, and architectural projects, not to mention his activities as Papal Inspector of Antiquities. His major pupils, such as Gian Francesco Penni and Giulio Romano, were, therefore, increasingly active helpers in the execution of his multifarious projects. Nevertheless, although varying opinions have been held on the subject, it is now generally thought that Raphael himself was responsible both for the design of the cartoons and for a very substantial part of their execution.

As a result of the removal of the superficial grime, it is now easier than ever to see Raphael's charcoal under-drawing in many of the more thinly painted parts. Occasionally, as in the squared pavement of *The Death of Ananias*, there is evidence of a complete change of plan. More often it is a question of the refinement of a

form, of slimming down and disciplining the preliminary, broad swift outlines until the definitive ideal has been achieved. Examples can be seen outside the final contours of Christ's pointing arm (pl. 25) in *Christ's Charge to St Peter* or in that of the kneeling figure holding the heifer (pl. 40) in *The Sacrifice at Lystra*. Elsewhere, as in the arm of the bearded figure on the far right of the Sacrifice, not only charcoal contour lines but broad, hatched indications of the planned distribution of light and shade are still visible. In the case of Elymas's sleeve (pl. 38) in *The Blinding of Elymas*, the bold under-drawing gives way to a broad brush hatching of the half-shadows which can be seen again in the draperies of St Paul (pl. 37) on the left of the same scene. Another cartoon in which the various stages of the development from bold initial ideas to the final strictly controlled form is very clear is *The Healing of the Lame Man* (pl. 3). Free under-drawing can be seen in the running child with the dove upon the left and in the kneeling beggar on the right (pls. 3, 30), whereas in the faded blue dress of the woman with the baby, also on the right (pl. 32), absolute control of the final fold form is established by a few bold lines in charcoal. The pricking of the contours which is everywhere apparent is not, of course, original and was carried out at some point by the weavers to assist in the making of accurate copies.

Needless to say, only the last adjustment of Raphael's already fully developed ideas can be seen on the surface of the cartoons themselves. By looking further back into his working processes and examining the few surviving preliminary drawings, something of the range of the work and thought behind each figure in a finished composition can be glimpsed. A magnificent red chalk preparatory drawing in the Louvre (pl. 24) shows one of Raphael's studio assistants posing for the figure of Christ during an early stage in the designing of *Christ's Charge to St Peter* (pl. 2). Fine as this first idea is, Raphael evidently felt that the heavenwards pointing gesture, taken over from Leonardo and previously used in his own fresco of *The School of Athens*, was both too hackneyed and too vague, and that the figure of Christ was too completely turned away from the sheep which were to be introduced behind Him. In the cartoon itself, the gentle, relaxed gesture has become a firm command (pl. 25). The taut, stretched arms, the straight, firm stance and carriage of the head, have now become a fitting vehicle for the full expression of the indwelling power and authority that lie behind the somewhat sad, still gentle, face of Christ.

For anyone who has looked at all at the cartoons themselves, there is little need to emphasize the boldness of design in figures such as that of Ananias (pl. 34), or of St Paul (pl. 37) in *The Blinding of Elymas*. It is matched by the gentle sensitivity that reaches back to Raphael's earliest Umbrian beginnings and gains in subtlety with every passing year of his career, to reach its peak in figures such as that of the woman with her baby (pl. 32) in *The Healing of the Lame Man* (pl. 3). There it makes a telling contrast to the Leonardesque ability to catch a character which is evinced in the cripples in that same cartoon (pls. 28, 30). In heads such as these the x-rays taken at the time of restoration vividly reveal that the boldness of the drawing was succeeded by a no less lively laying on of the underpaint (pl. 29). The vigour of the lower layers of brush work thus disclosed shows that in Raphael's mature work discipline in the outcome is never a synonym for timidity in the execution.

The final prerequisite for a full appreciation of the range of Raphael's achievement is that the individual beauty of the cartoons should be seen in their original context as designs which, when translated into tapestry, were to complete the decoration of the Sistine Chapel. This is especially the case since van Aelst used the low warp method of weaving. In this system the loom was horizontal like an ordinary cloth loom. The weaver worked with the back of the tapestry uppermost and the cartoon faced him beneath the warp. This meant that the tapestries were always a mirror image of the designs from which the weaver worked. Consequently, with this process in mind, Raphael painted his cartoons entirely in reverse. The effect of this procedure upon Raphael's designs has been the subject of much discussion. It has even been suggested that at times he became confused. On the contrary, all the evidence seems to show that at every stage Raphael knew exactly what he was doing. This is not surprising, as the process of designing in reverse, which tends to sound so daunting to a layman, is much less of a problem to an artist. Every woodcut, etching, or engraving, is, after all, the outcome of an analogous reversal of an original design which has first been drawn and then carved, scratched, or cut upon the block or plate. The Louvre drawing for the figure of Christ (pl. 24) in *Christ's Charge to St Peter* and an offset for the figure composition as a whole, which is preserved at Windsor, show that Raphael's procedure was firstly to draw his compositions in the cartoon direction and then to check, by various means, the precise effects which would result from the reversal of the design in the tapestries towards which his every effort was directed.

The cartoons, and the tapestries in their setting

When Raphael accepted the commission to design narrative tapes-

tries to complete and to enhance the decoration of the Sistine Chapel on major ceremonial occasions by covering the existing, painted hangings, which covered the lower walls, he faced an intimidating task. The middle zone of all four walls had been frescoed in 1480–82 with scenes from the Old and New Testaments. These had run, respectively, from above the altar, surmounted by Perugino's frescoed altar-piece, down the left and right sides of the chapel to its entrance. A galaxy of the greatest names in fifteenth century painting, including Signorelli, Botticelli, and Raphael's own master, Perugino, had co-operated on the task. Immediately above these frescoes, in the spaces between the windows, stood the painted figures of the Popes. Finally, in the vault there was Michelangelo's ceiling of the Creation and Fall, the Sybils and Prophets, and the Ancestors of Christ. Completed only three years earlier, in 1512, this was the acknowledged wonder of the Renaissance world. Raphael was, therefore, faced not merely with a complex decorative problem, but with creating compositions which could stand direct comparison with Michelangelo's masterpiece.

The Sistine Chapel is a vaulted hall some 40.23 metres long and 13.41 metres wide, with six windows on each side. The long walls are divided into six bays by their painted decoration. The most striking change which has overtaken the Chapel since Raphael surveyed it is the replacement of the windows and of the fifteenth century frescoes on the altar wall by Michelangelo's *Last Judgement*. In addition, the raised area on which the altar and the Papal throne stand has been slightly modified. Finally, the screen or *cancellata*, which formerly ran across the Chapel to meet the singing gallery and therefore cut the room almost exactly in half, was later moved and now encloses about two-thirds of the Chapel within the chancel area.

Although the question of the original arrangement of Raphael's tapestries was long the subject of controversy, it now seems likely that the matter has been settled at least as far as the main scenes and the lower borders are concerned.[2] The diagram in plate 8 illustrates the probable solution.

The tapestries involving Christ and St Peter (pls. 9–12) began on the right of the altar and ran down the adjoining wall beneath the similar scenes in the fifteenth century frescoes of the New Testament. They extend as far as the singing gallery. Those devoted to St Paul (pls 13–18) occupied similar positions on the opposite side of the chapel, underneath the Old Testament frescoes, and reached the bay beyond the *cancellata*. All the tapestry scenes followed the chronological order given in the Gospels and the Acts and listed on page 3 above with reference to the cartoons. These, as they are now hung, in a vaulted hall which has very similar dimensions to those of the Sistine Chapel, present a mirror image of the arrangement of the tapestries.

The strong fall of light from right to left in the cartoons devoted to Christ and to St Peter, and from left to right in those concerned with St Paul, was specifically intended to make it appear that the reversed designs of the tapestries were, like all the earlier painted decorations of the Chapel, consistently lit by the windows then set in the altar wall. Variations in the fall of light are no less carefully handled in the fictive bronze-relief lower borders of the tapestries. They are among the reasons which leave little room for doubting that the tapestries with borders dealing with the main religious events of Leo X's life were placed on the altar wall, while the secular events from the story of the Medici Pope ran down the right wall. On the other side of the chapel, the similar borders were devoted to further scenes from the Acts, dealing mainly with the life of St Paul. The reconstruction of the original number and placing of the lateral borders devoted to the *Seven Liberal Arts* (*Quadrivium* and *Trivium*), the *Seven Virtues* (*Theological* and *Cardinal*), *The Hours*, *The Seasons*, *The Elements*, and *The Labours of Hercules*, is a much more complicated matter. The number and the order shown in the diagram is only hypothetically correct. What is in no sense controversial is the virtuosity with which Raphael completed the thematic and the decorative orchestration of the Chapel.

In Michelangelo's ceiling, the first days of creation, in which the figure of God as a pure spirit hurtles through the sky, are set immediately above the first bay, occupied by the raised platform of the altar. In the right half of this same area Raphael placed the two scenes in which Christ Himself appears in the flesh. In the left half were the two tapestries with the heavenly apparitions of Christ, first to St Stephen and then to Saul. These four tapestries were further united with each other and distinguished from the remainder by being the only pure landscape scenes in the set. Raphael was, moreover, at great pains to stress the continuity of these landscapes. When the cartoons of *The Miraculous Draught of Fishes* (pl. 1) and *Christ's Charge to St Peter* (pl. 2) were reversed in tapestry (pls. 9, 10), the rising, flower-strewn bank ran on exactly from one scene to the next. The bow of the boat cut off behind the figure of Christ in *The Miraculous Draught of Fishes* appears pulled to the shore in the succeeding scene. Even the tip of promontory above the seated Christ is continued in the background hills of *Christ's Charge to St Peter*. Similarly, the stony foreground and a distant snowy range of

[2] See J. White and J. Shearman, 'Raphael's Tapestries and their Cartoons' in *Art Bulletin*, vol. xl, 1958, pp. 193–221, 299–323.

hills were used to establish continuity in the two landscapes on the opposite side of the altar (pls. 13, 14).

The second bay in the Sistine Chapel is the centre of the three bays which were enclosed within the chancel by the *cancellata*, and Raphael recognized the fact in the splendidly centralized architectural designs of *The Healing of the Lame Man* (pl. 11) and the now seriously mutilated *Blinding of Elymas* (pl. 17). The links between the former and *The Death of Ananias* (pl. 12) were strengthened by the background rectangles of landscape which, in the tapestries, become continuous (pls. 11, 12). On the opposite wall *The Blinding of Elymas* and *The Sacrifice at Lystra* (pls. 17, 16) are united by the splendid columnar forms of their Renaissance Roman architecture.

On the left wall of the Chapel the small remaining fraction of a bay was occupied by the narrow strip of the *St Paul in Prison* (pl. 15), with the Saint praying towards the altar. At this point the lower walls of the chancel were completely covered and the principal architectural division of the Chapel was reached. In Michelangelo's ceiling this separation of the clergy from the laity was recognized in the crucial iconographic division between the Creation and the Fall and Degradation. For Raphael, the need to recognize the architectural division was even more acute, since the *cancellata* formed an actual barrier between one tapestry and the next, and his response was typically ingenious. In the tapestry of *St Paul Preaching at Athens* (pl. 18), the perspective centre is offset to the left, and St Paul giving his message to the philosophers, the laymen, and the gentiles of Antiquity preaches also to the laymen in the Chapel. The great flight of steps on which he stands is a monumentalization of the single low step down, which marks the architectural division in the floor of the Chapel.

The weight of evidence indicates that no more tapestries were ever designed and that the set as it stands is, therefore, complete, even though it does not wholly cover the walls of the Chapel. Whether or not this is actually the case, there can be no doubt that in every detail of his grand design Raphael, like Michelangelo before him, paid the strictest attention to the architectural and functional organization of the Chapel which it was his task to decorate.

Although the carrying out of his intentions in reverse in the cartoons caused Raphael relatively little difficulty and certainly led to no confusion in his mind, it does necessitate a special effort of the imagination from the observer. First, there is the visual disjunction of the specific continuities of landscape which have already been discussed. Secondly, apart from the unbiquitous left-handed gestures, there is the reversal of the carefully calculated compositional flow of movement within each design and from one tapestry to the next.

In the cartoon of *The Miraculous Draught of Fishes* (pl. 1) and in *Christ's Charge to St Peter* (pl. 2) all the pressure of the design is from right to left. Since the usual tendency is to read a design from left to right, the eye moves on from the figure of Christ on the extreme left to be continuously pressed back and opposed by the movement of the apostles on whom enormous compositional stress is therefore placed. Magnificent as are such figures as the pair who are straining at their nets (pl. 22), it was not on them, but upon Christ that Raphael actually designed the emphasis to fall, and in the tapestries (pls. 9, 10) it does so. In both of the tapestries, the figures sweep from left to right and the observers's eye sweeps with them to its focus in the all-important figure on the extreme right. This same movement also stresses the natural left to right progress along the Chapel wall from one scene to the next. In the succeeding tapestry of *The Healing of the Lame Man* (pl. 11), on the other hand, the recognition of its central position leads to a balancing of the design. A calmer initial movement towards the right is matched by a firmer, more extended counter-movement in the right half of the composition.

The biggest change of all occurs perhaps in the design of *The Death of Ananias*. The cartoon (pl. 4) is amongst the most grandly calm and the most classical of Raphael's mature compositions. The apostles stand at the hub of the still, compositional circle. The eye moves swiftly past the recoiling figure on the left to focus on the tragic grace of the dying Ananias and to be held there by the advancing wall of figures. In the mirror-image of the cartoon and of course in the tapestry (pl. 12), the situation is very different. Instead of the impression of a balanced, static circle, there is a steady compositional flow, which culminates in the group around St John, who no longer appears as the centre of an almost self-contained secondary action. There is new emphasis upon the recoiling figure who is now on the right of the central gap, and Ananias is flung back against the compositional flow with what appears now to be horrifying awkwardness. Just as the violence and the expressive compositional conflicts of the Stanza d'Eliodoro and the Stanza dell'Incendio succeed the calm, harmonious grandeur of the Stanza della Segnatura, so, in the tapestry designs, Raphael embodies joyful episodes in peaceful, classically balanced or harmoniously moving compositions, and expresses violent or dramatic moments

by tension in design and by sudden reversals of the compositional flow.

In the tapestries devoted to St Paul, on the left wall of the Chapel, Raphael was naturally concerned both to initiate and then to maintain a steady right to left compositional flow which would reflect the need for progress in a right to left direction along the wall. At the beginning of the main wall, in the dramatic scene of *The Conversion of Saul* (pl. 13), the movement is not merely strong but violent. Next there comes the more balanced, centralized design of *The Blinding of Elymas* (pl. 17), the cartoon for which (pl. 5) has lost the major architectural feature which formerly closed the composition on its left. Here, the gesture of the figure of St Paul has such compelling force that Elymas, set as he is against the compositional flow, seems rooted to the spot (pl. 38). In the tapestry direction on the other hand (pl. 17), the blinded figure still appears to be in hesitant, forwards-groping motion and is a perfect illustration of the words in Acts xiii: 'And immediately there fell on him a mist and a darkness; and he went about seeking someone to lead him by the hand.'

As the influence exerted by the tapestries on Poussin and on the French classicists until the end of the eighteenth century and beyond, and by the cartoons upon English painters such as Reynolds and Barry, Fuseli and Haydon, fully demonstrates, the cartoons and the tapestries, for all the problems of reversal, should be seen as complementaries, not as competitors in some irrelevant aesthetic battle. Each have their special qualities. Each add new dimensions and new richness to the understanding and enjoyment of the other.

In compensation for the fact that the cartoons are a mirror-image of Raphael's final compositional intention, no weavers and no change of medium are interposed between the artist and the onlooker. The Masacciesque grandeur of St Paul in *The Blinding of Elymas* (pls. 5, 37), the calm simplicity of form derived from Giotto and transformed to his own purposes by Raphael in the *St Paul Preaching at Athens* (pls. 7, 41), can speak directly to the observer. The brilliance of the painting adds its special quality to the details from antiquity, whether in the twisted columns of *The Healing of the Lame Man* (pls. 3, 31), or in the altar in *The Sacrifice of Lystra* (pl. 6). Last, but not least, the subtlety with which Raphael, following in the tradition of the great Florentine and Central Italian narrative painters from Giotto and Masaccio to Leonardo and Michelangelo, catches nuances of psychological expression in each character, and delineates each individual's instantaneous and wholly personal reaction to the dramatic moment, can be savoured to the full.

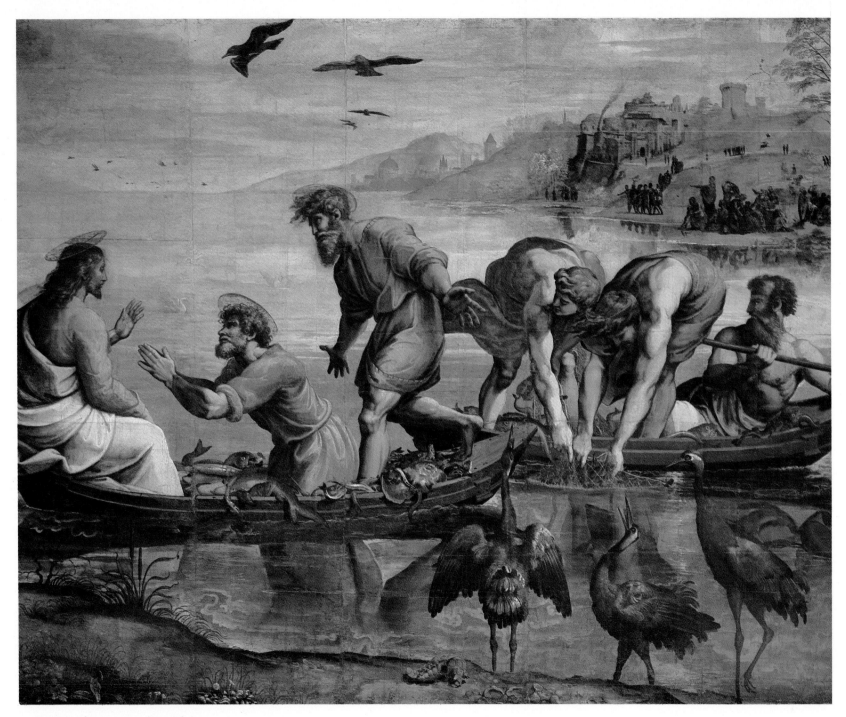

1. The Miraculous Draught of Fishes

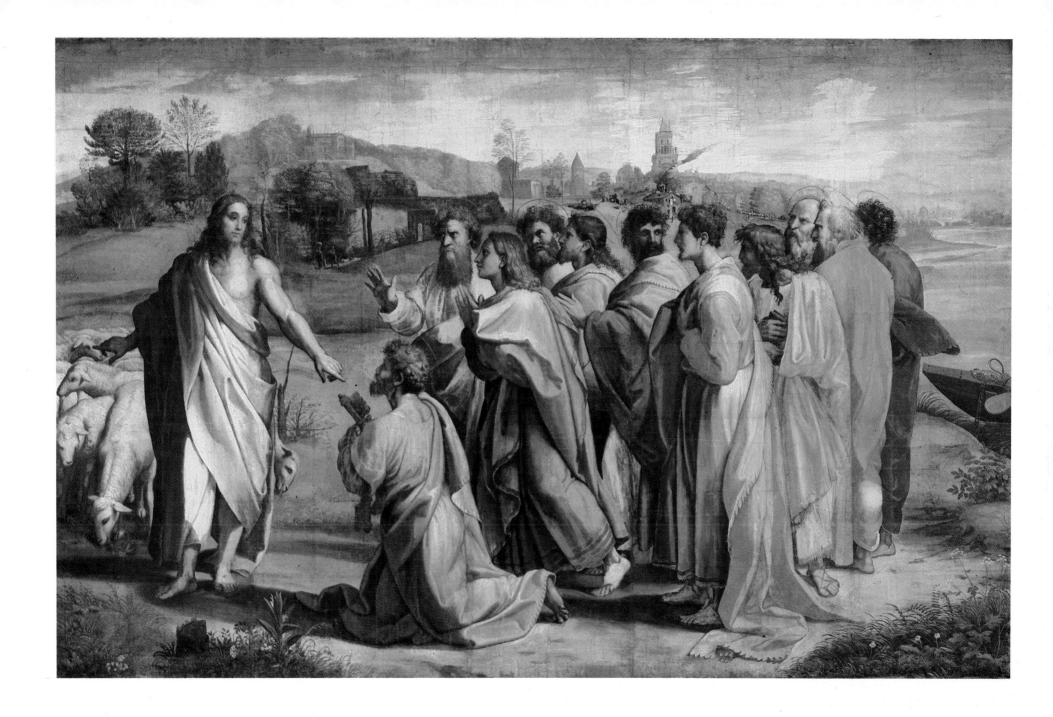

2. Christ's Charge to St Peter

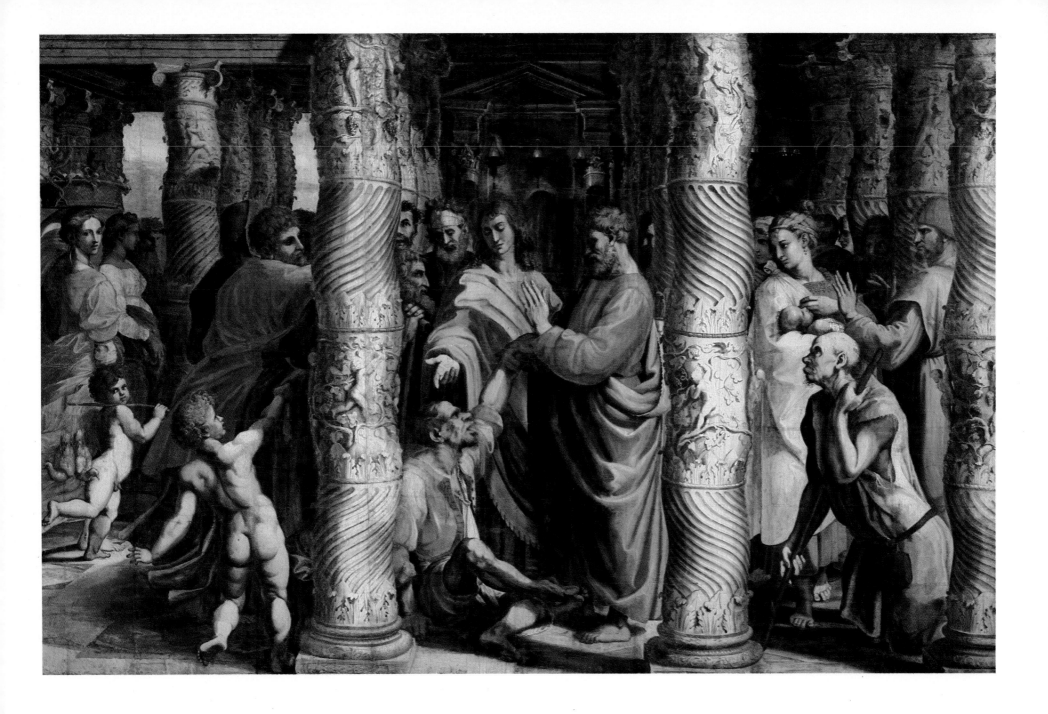

3. The Healing of the Lame Man

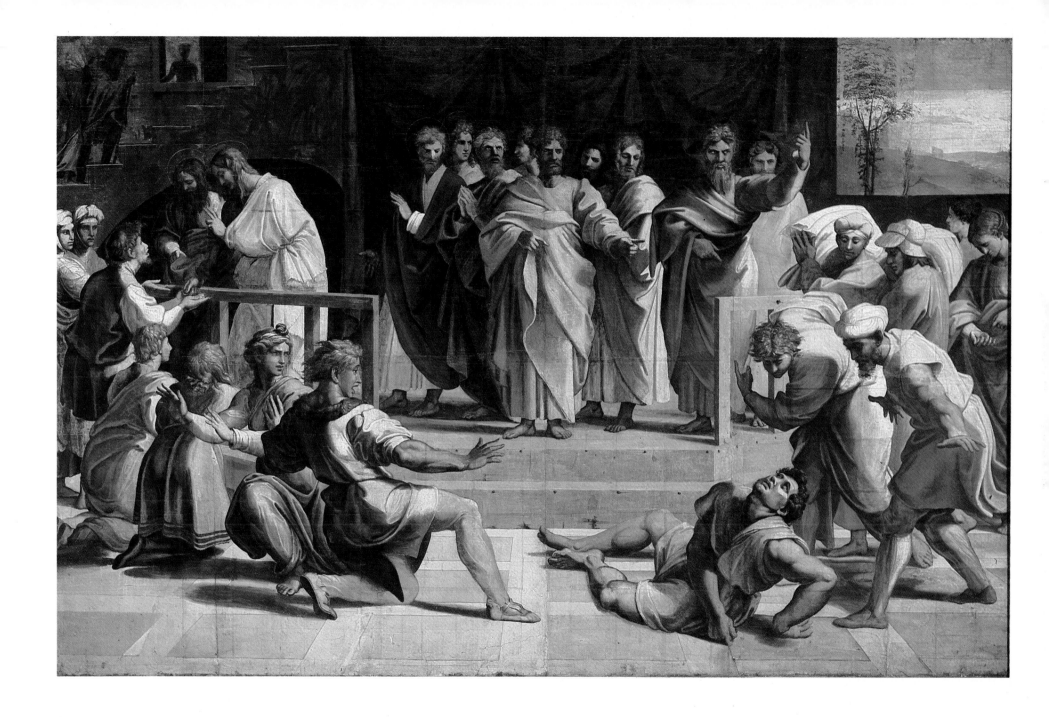

4. The Death of Ananias

5. The Blinding of Elymas

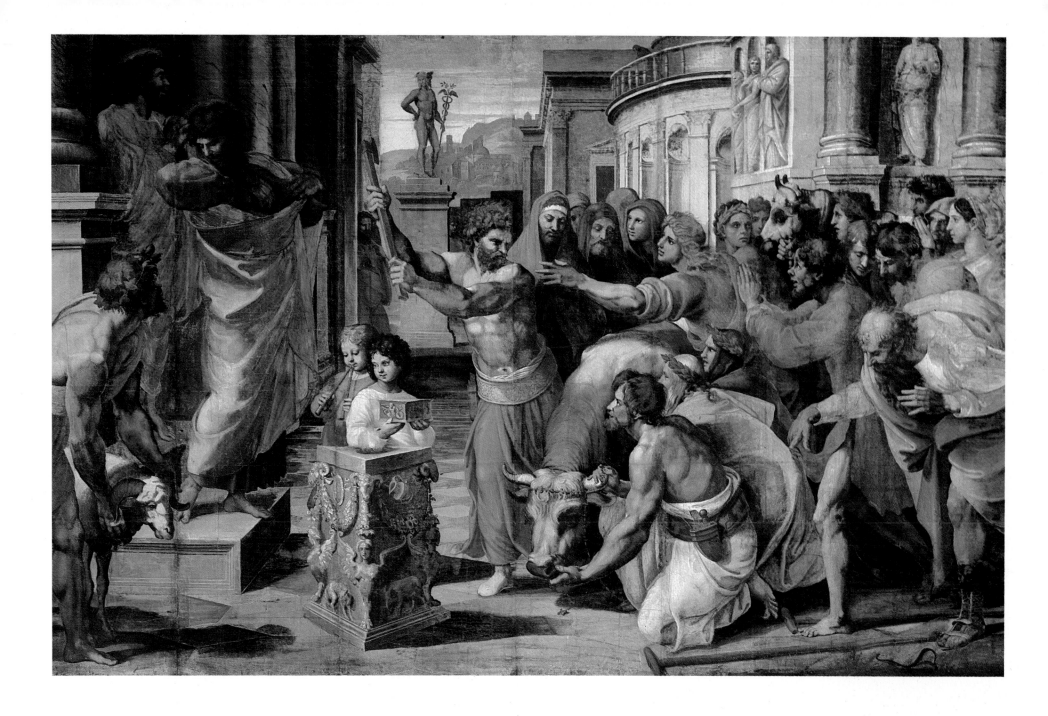

6. The Sacrifice at Lystra

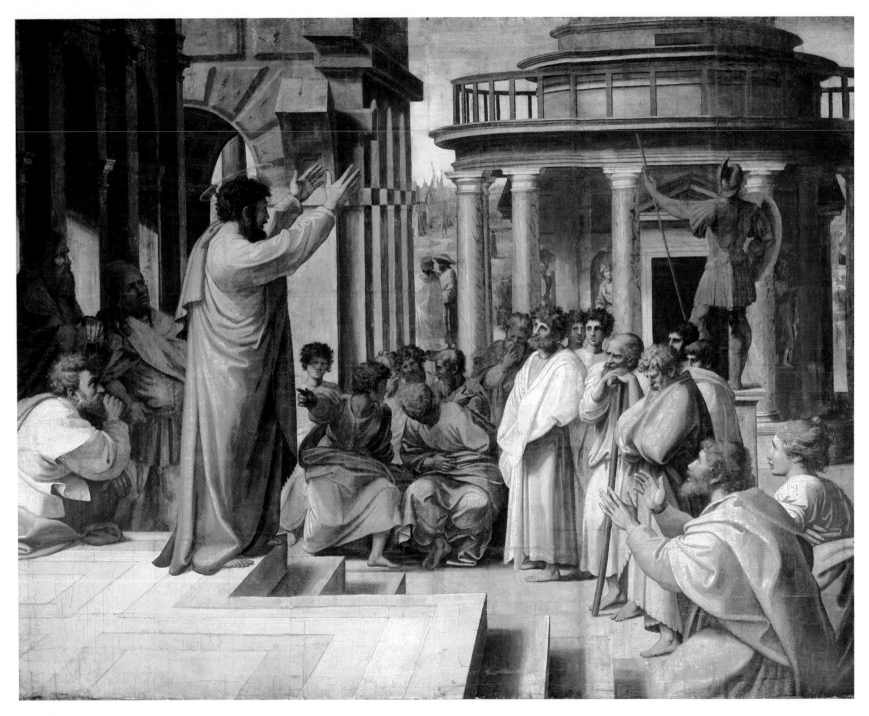

7. St Paul Preaching at Athens

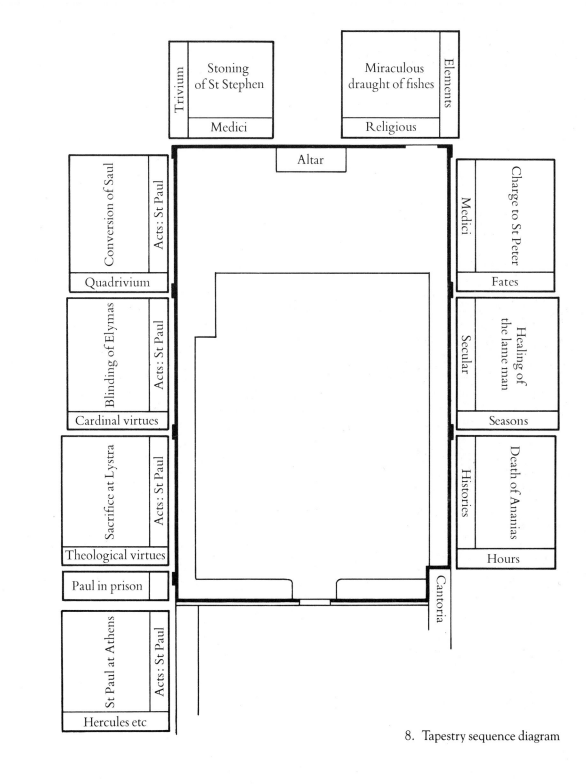

8. Tapestry sequence diagram

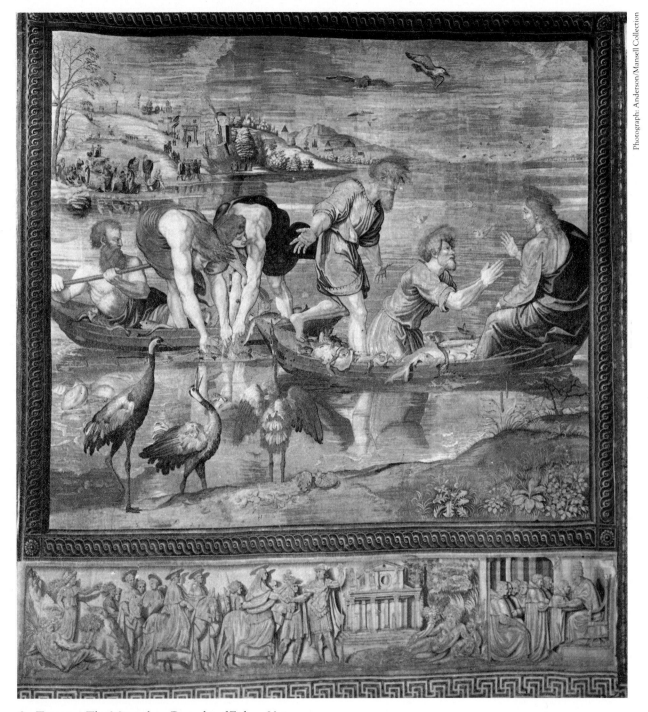

9. Tapestry: The Miraculous Draught of Fishes. *Vatican*

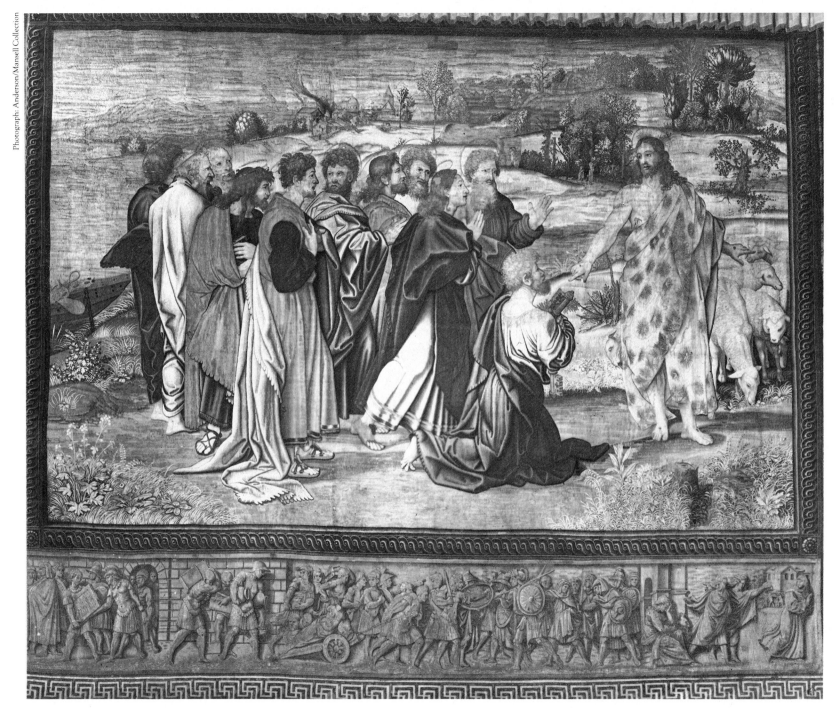

10. Tapestry: Christ's Charge to St Peter. *Vatican*

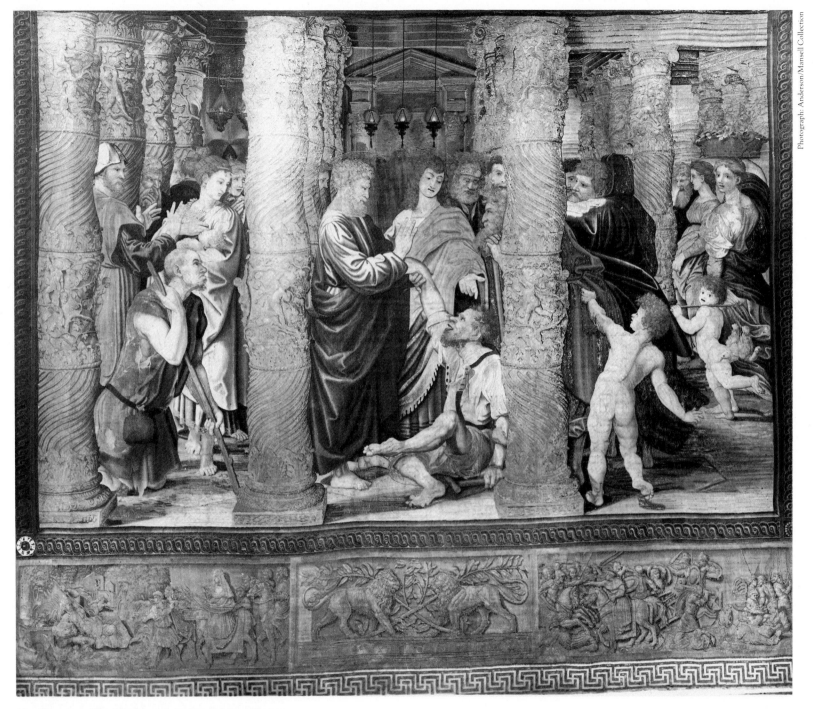

11. Tapestry: The Healing of the Lame Man. *Vatican*

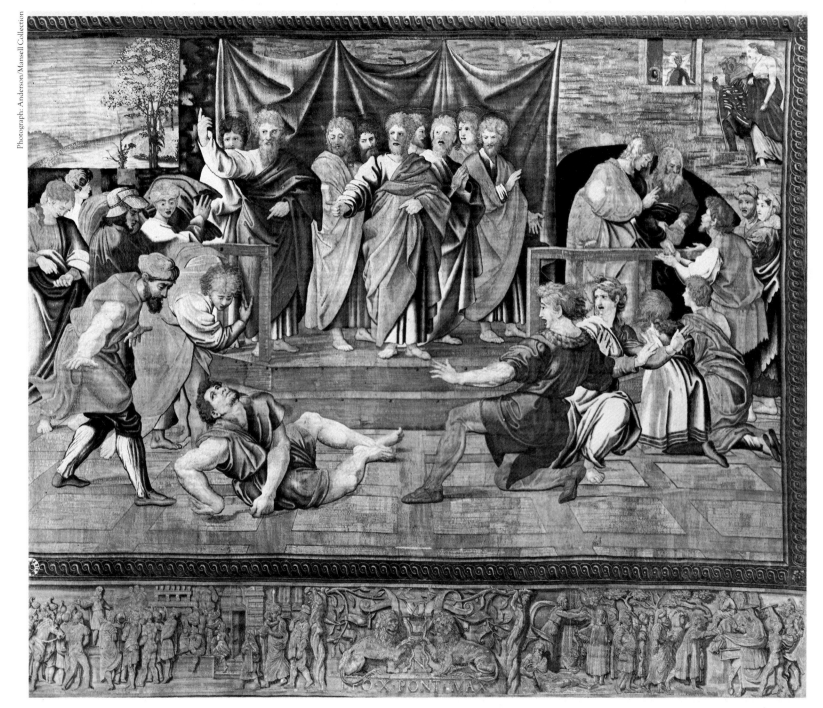

12. Tapestry: The Death of Ananias. *Vatican*

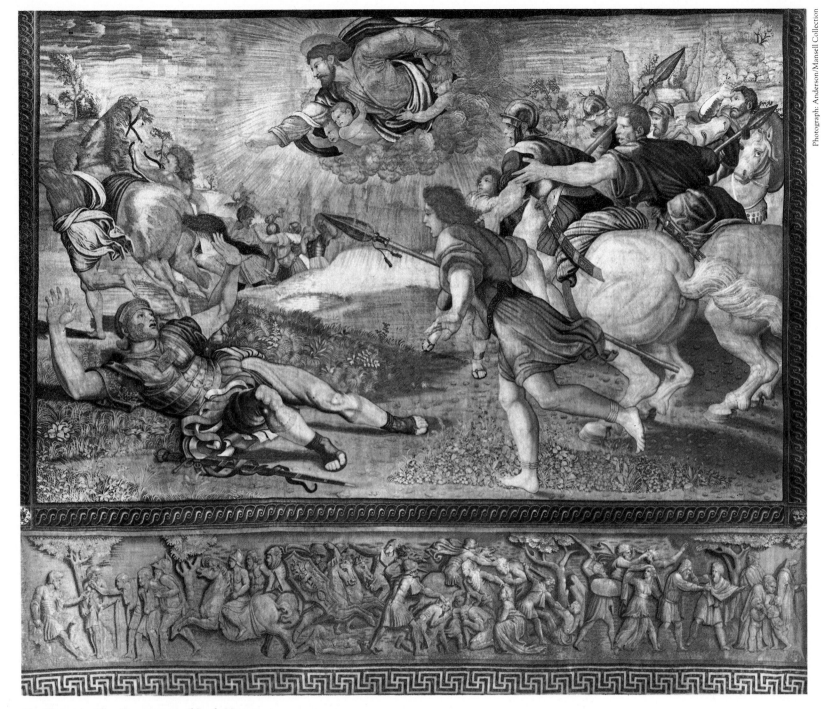

13. Tapestry: The Conversion of Saul. *Vatican*

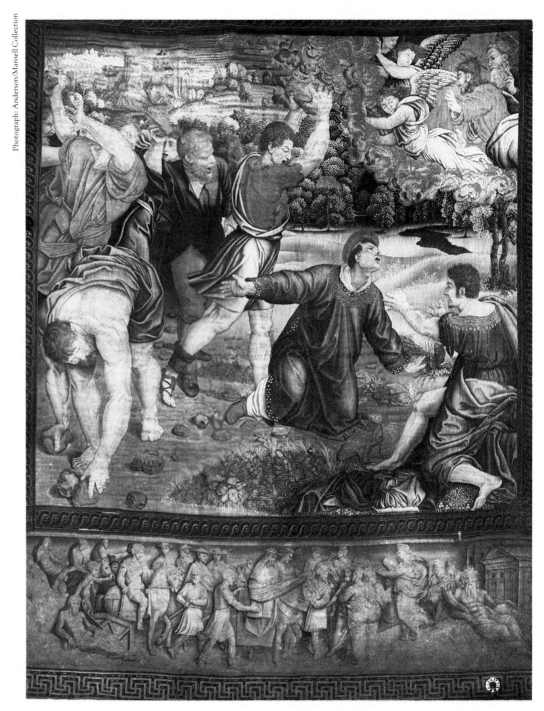

14. Tapestry: The Stoning of St Stephen. *Vatican*

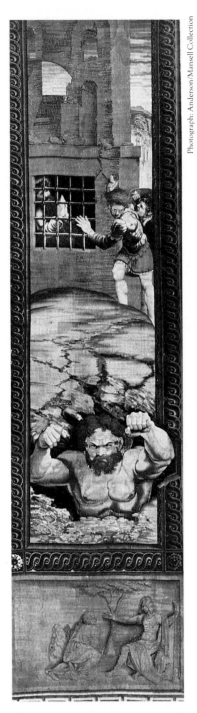

15. Tapestry: St Paul in Prison. *Vatican*

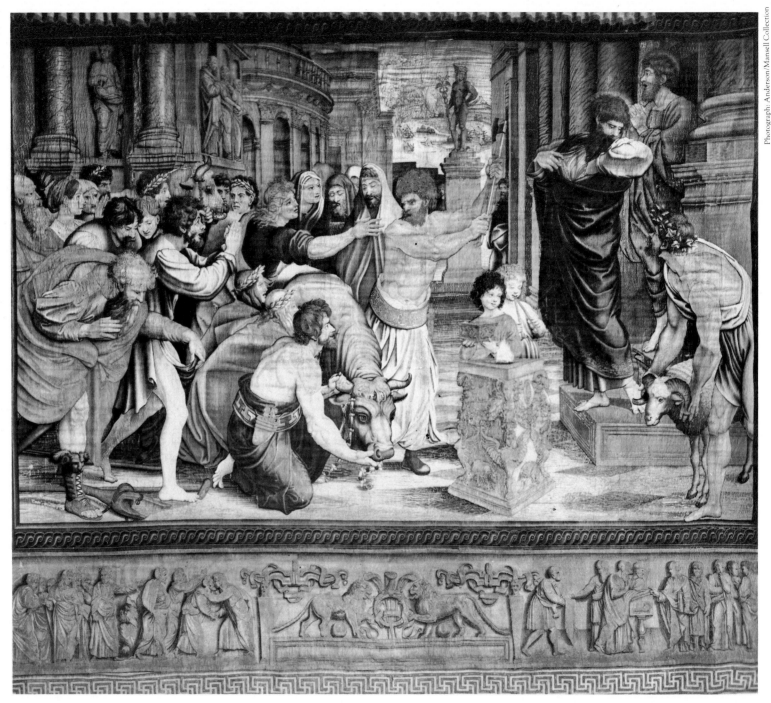

16. Tapestry: The Sacrifice at Lystra. *Vatican*

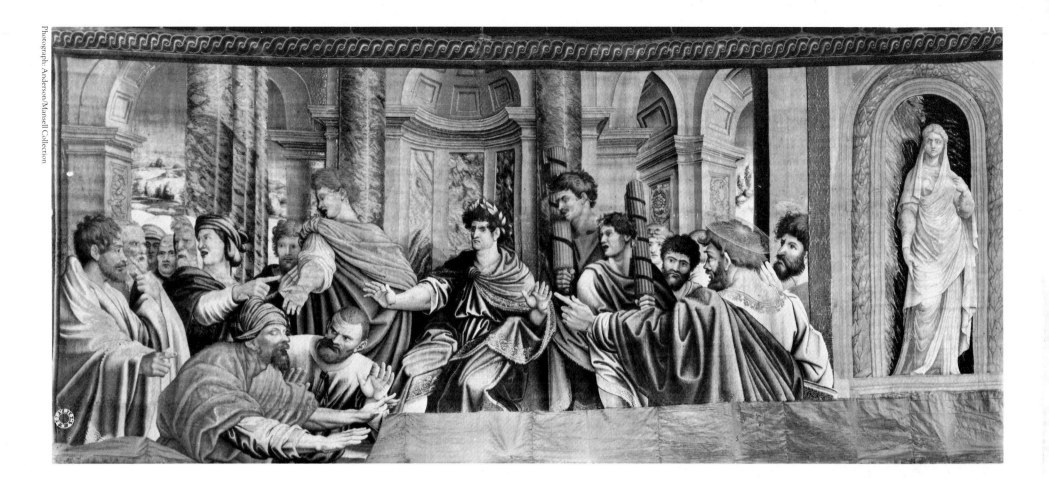

17. Tapestry: The Blinding of Elymas. *Vatican*

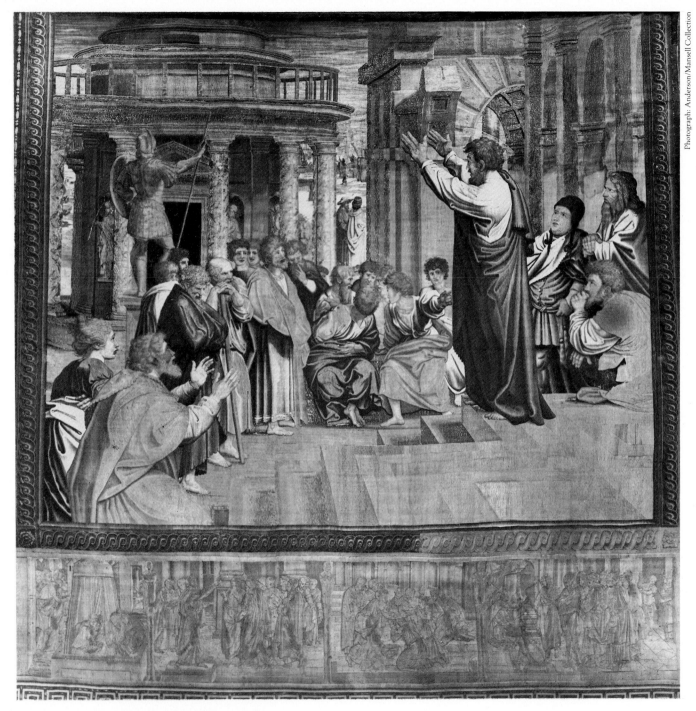

18. Tapestry: St Paul Preaching at Athens. *Vatican*

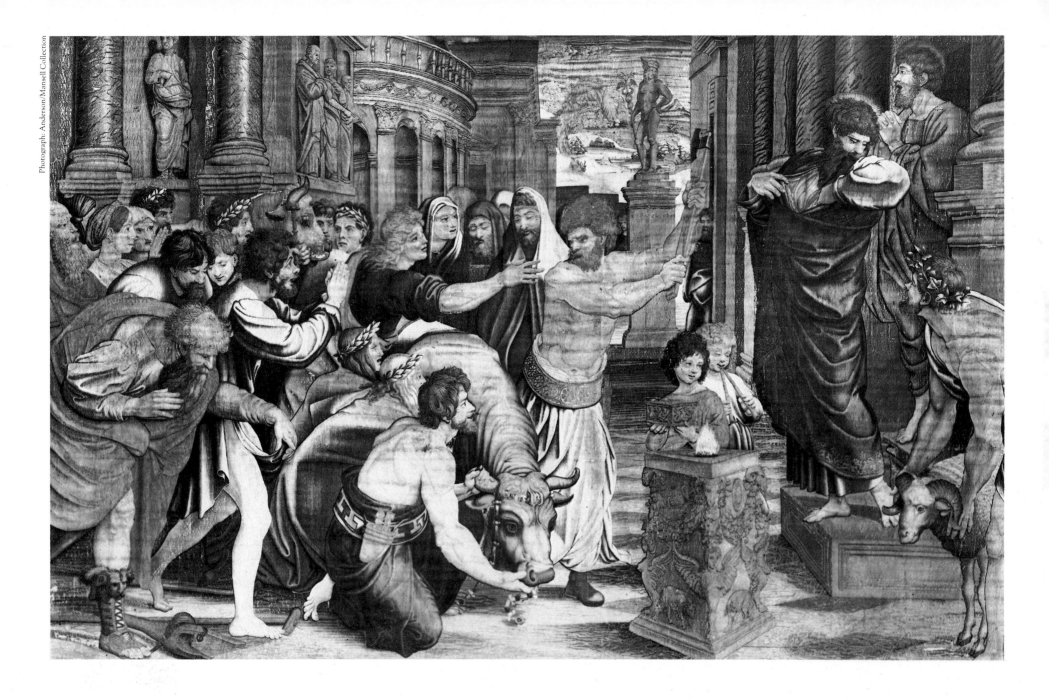

19. Mortlake tapestry: The Sacrifice at Lystra. *Garde-Meuble, Paris*

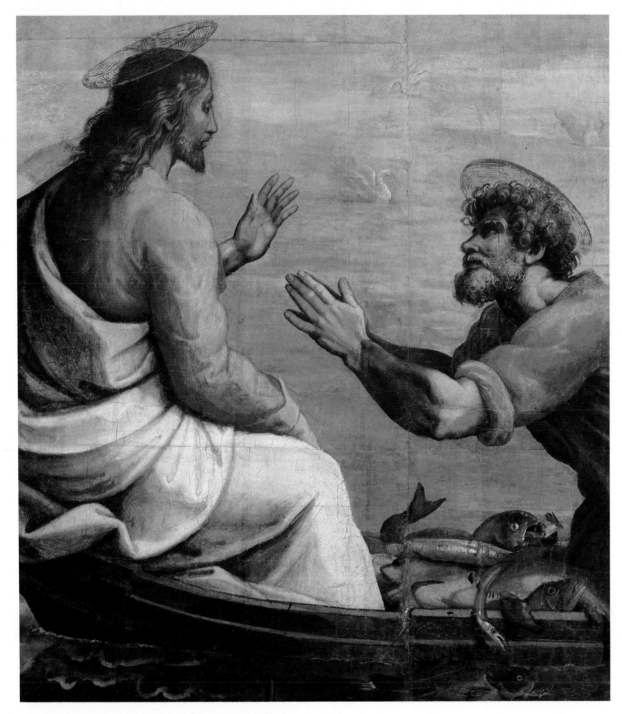

20. The Miraculous Draught of Fishes. Detail, Christ

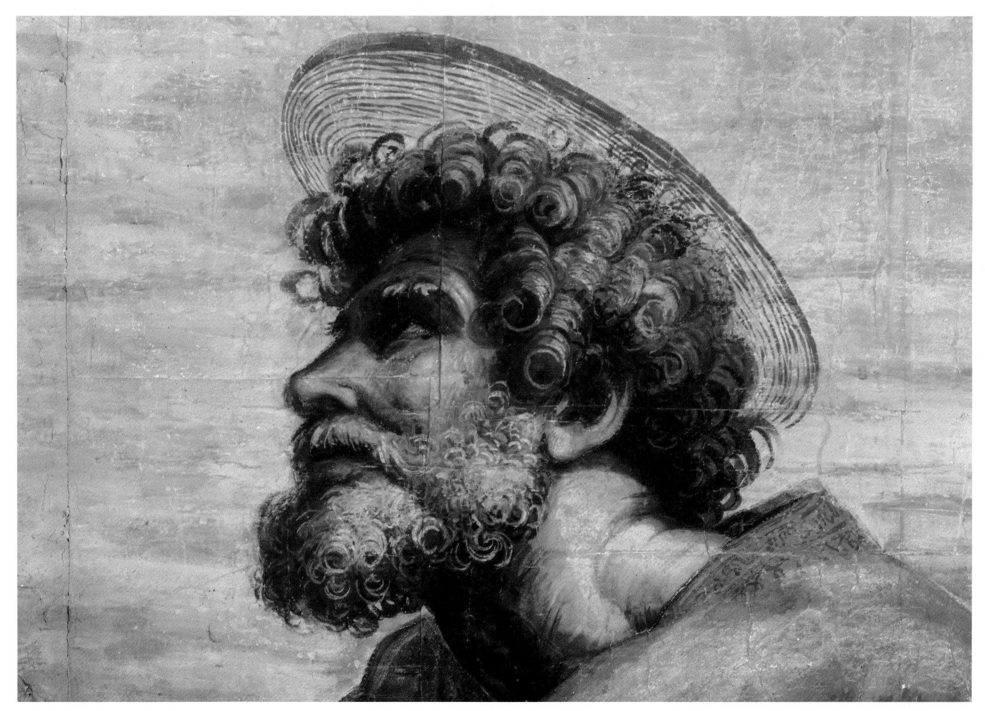

21. The Miraculous Draught of Fishes. Detail, St Peter

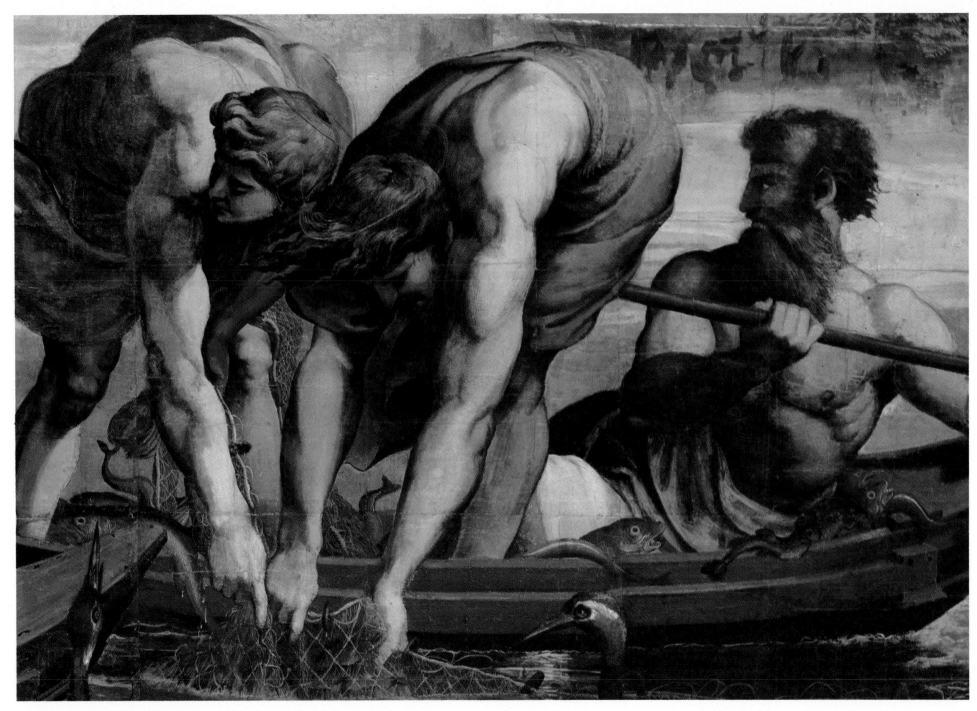

22. The Miraculous Draught of Fishes. Detail, St John and St James raising the net

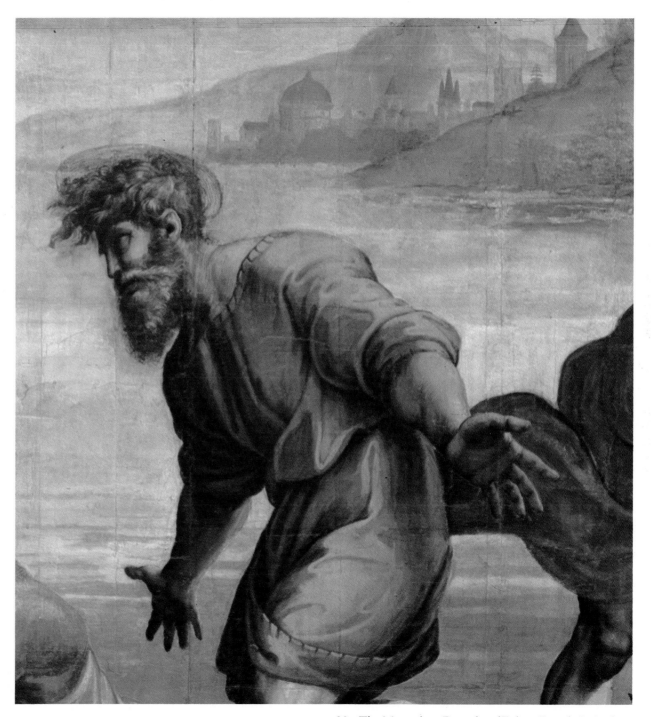

23. The Miraculous Draught of Fishes. Detail, St Andrew

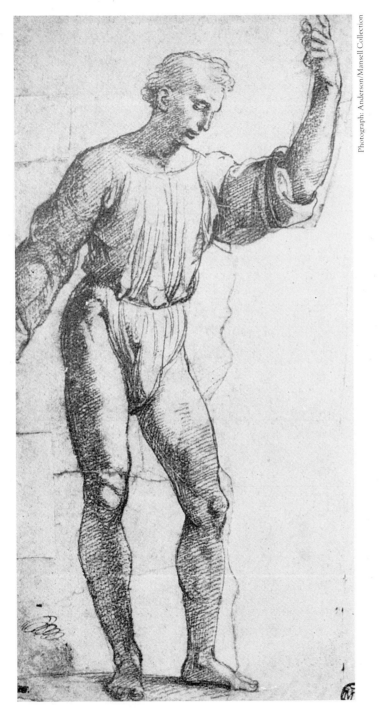

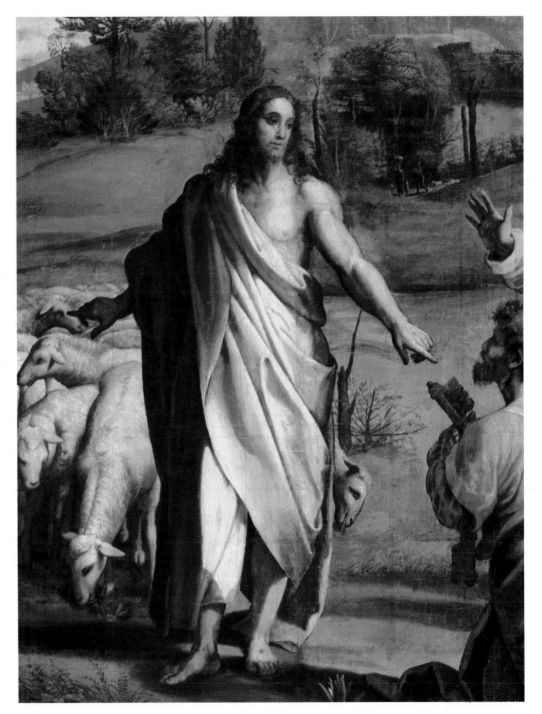

24. **Study for Christ in Christ's Charge to St Peter.** *Louvre, Paris*

25. **Christ's Charge to St Peter. Detail, Christ**

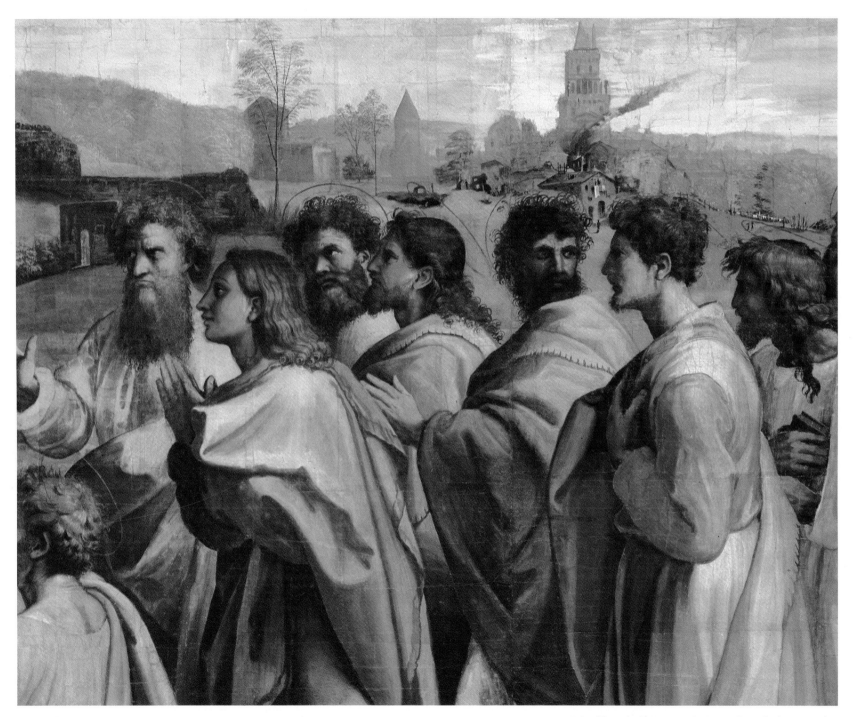

26. Christ's Charge to St Peter. Detail, the Apostles

27. Christ's Charge to St Peter. Detail, landscape

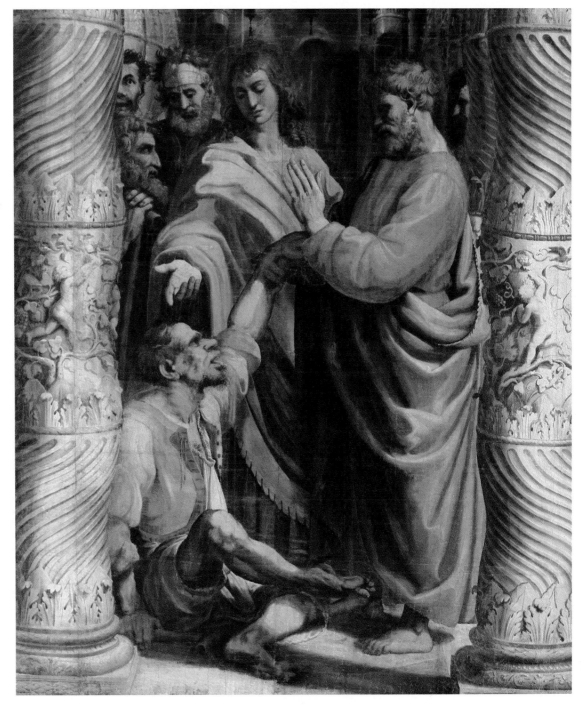

28. The Healing of the Lame Man. Detail, St Peter and St John

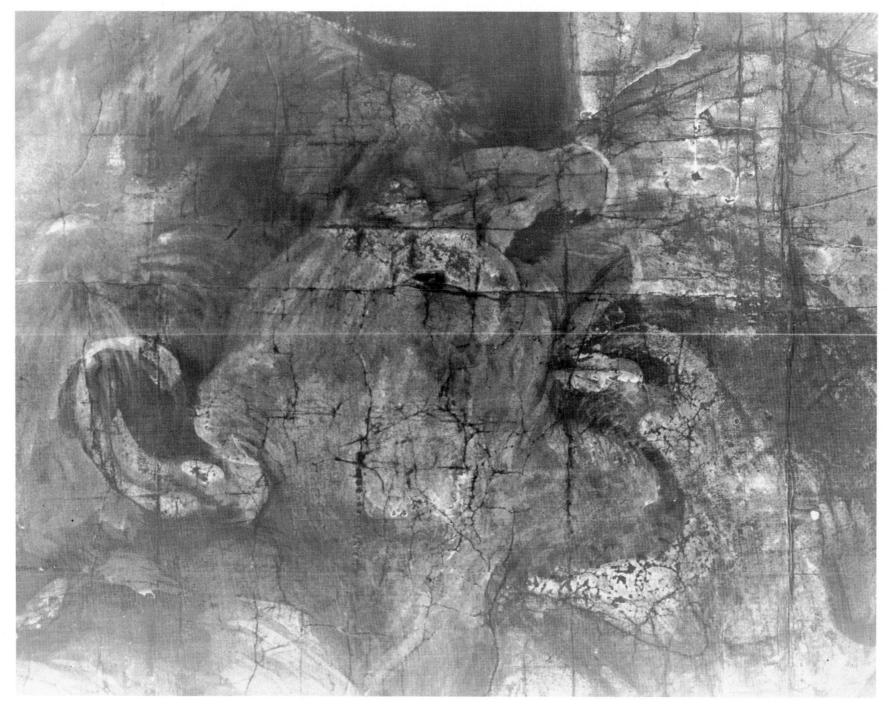

29. The Healing of the Lame Man. Detail, x-ray of the head of the Lame Man

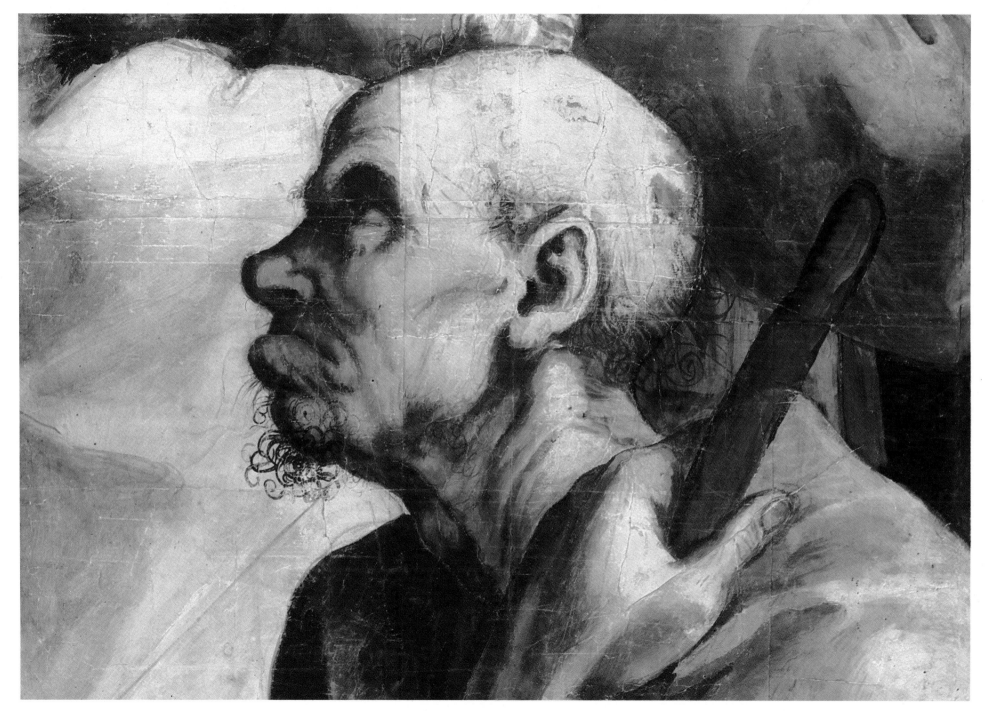

30. The Healing of the Lame Man. Detail, head of a beggar

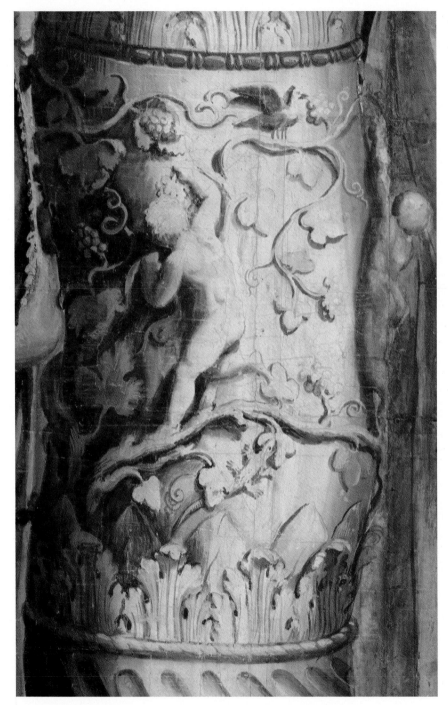

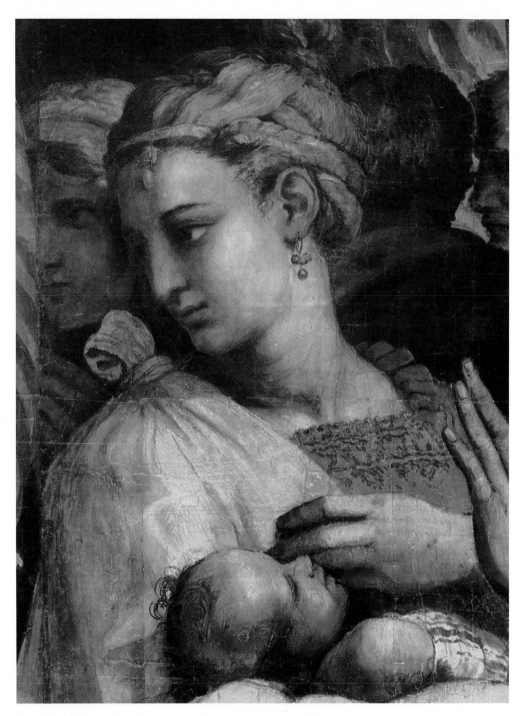

31. The Healing of the Lame Man. Detail, decoration of column

32. The Healing of the Lame Man. Detail, woman and child

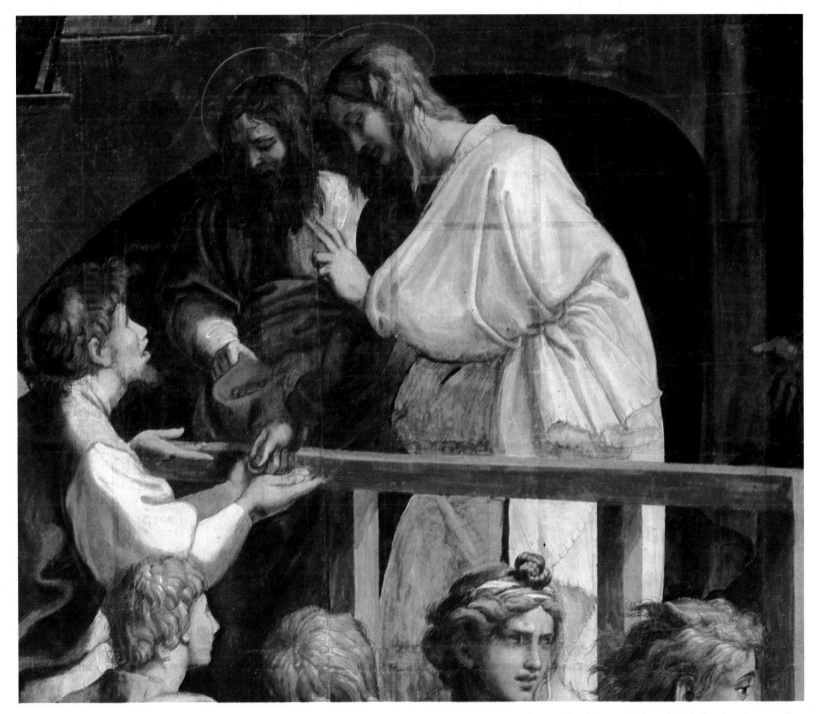

33. The Death of Ananias. Detail, St John distributing alms

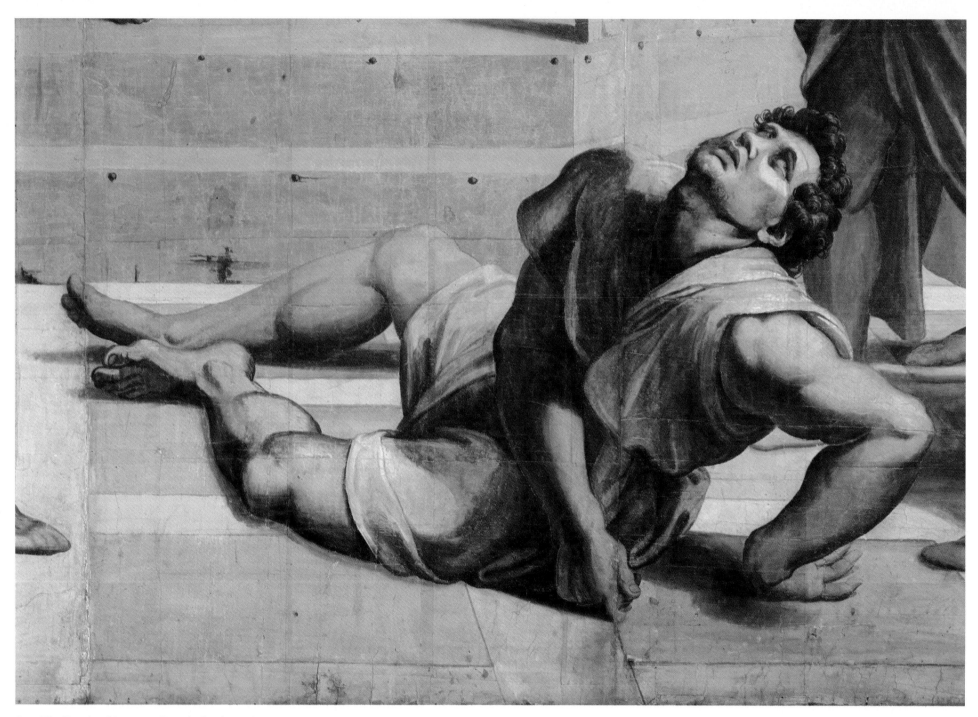

34. The Death of Ananias. Detail, the dying Ananias

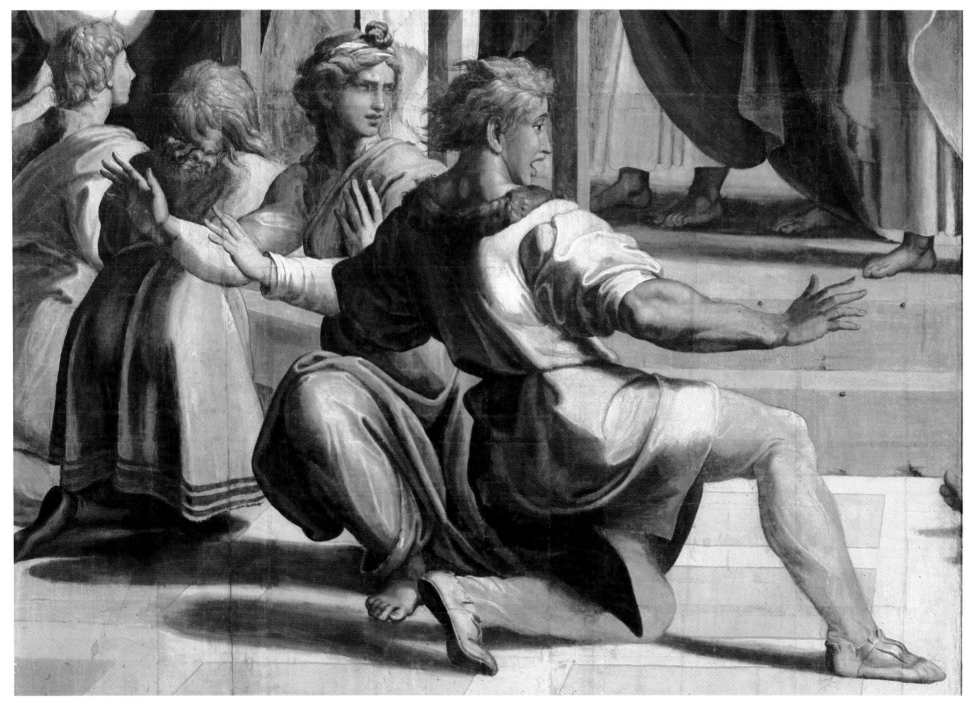

35. The Death of Ananias. Detail, horrified onlookers

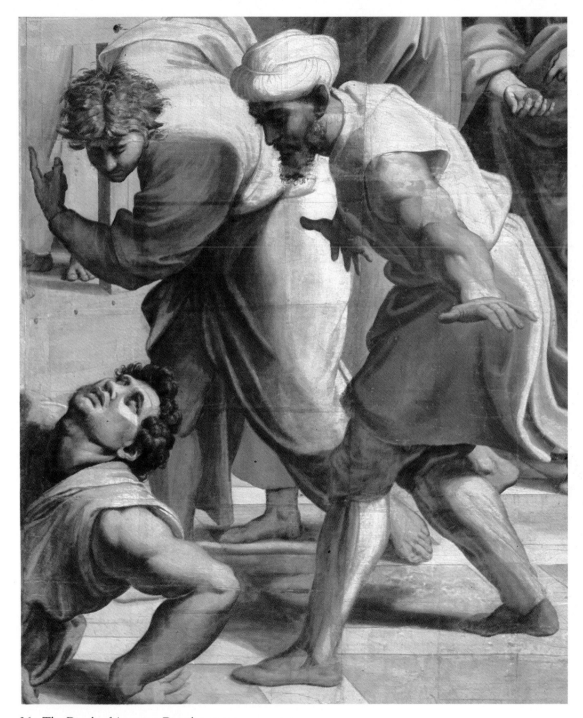

36. The Death of Ananias. Detail, spectators reacting

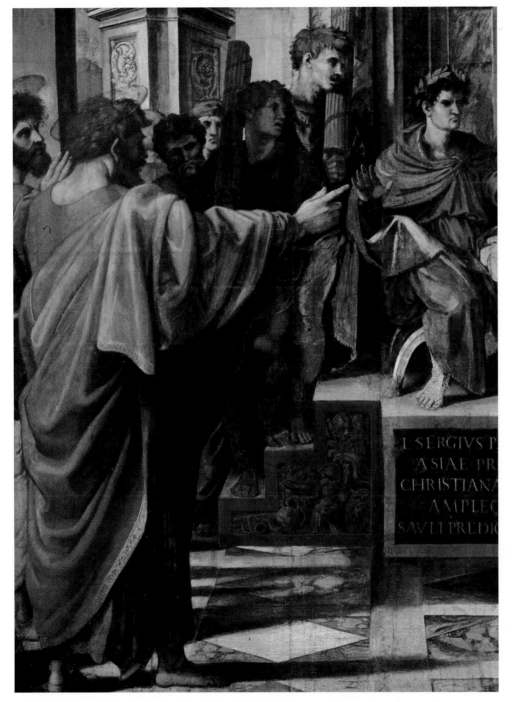

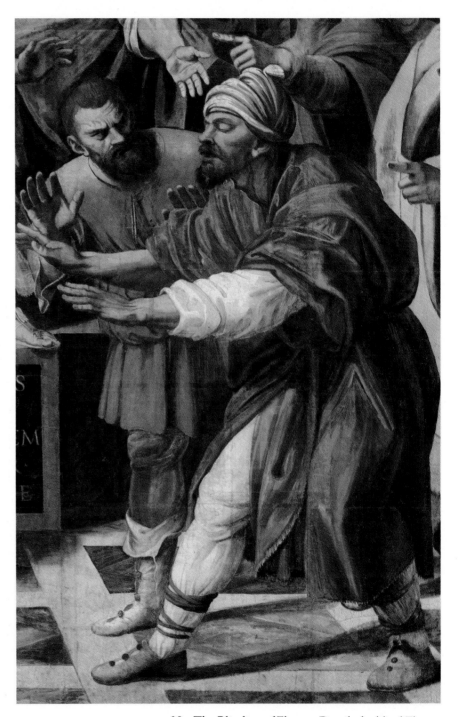

37. The Blinding of Elymas. Detail, St Paul

38. The Blinding of Elymas. Detail, the blind Elymas

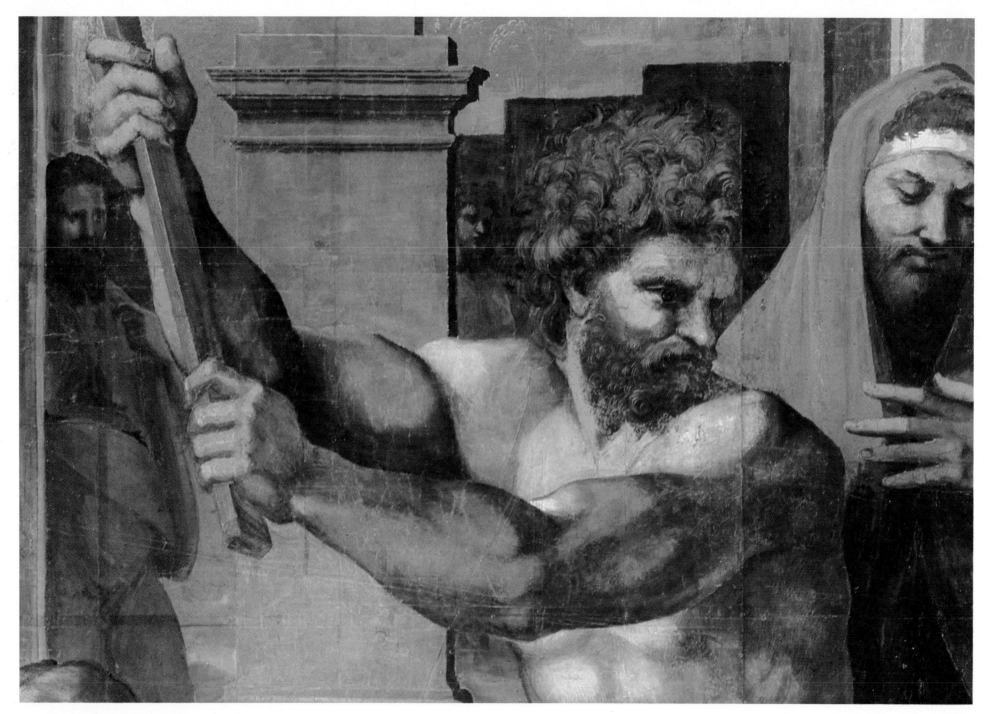

39. The Sacrifice at Lystra. Detail, man with sacrificial axe

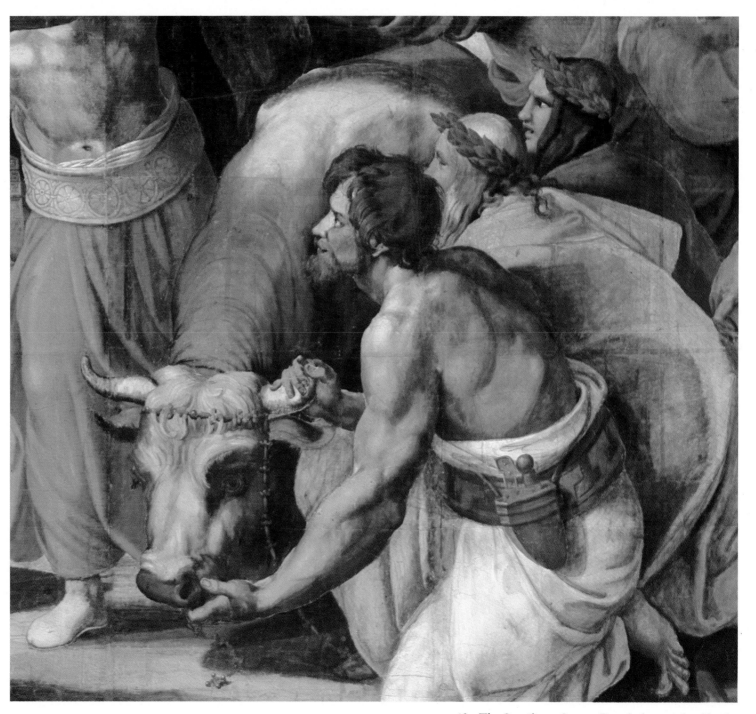

40. The Sacrifice at Lystra. Detail, the sacrificial heifer

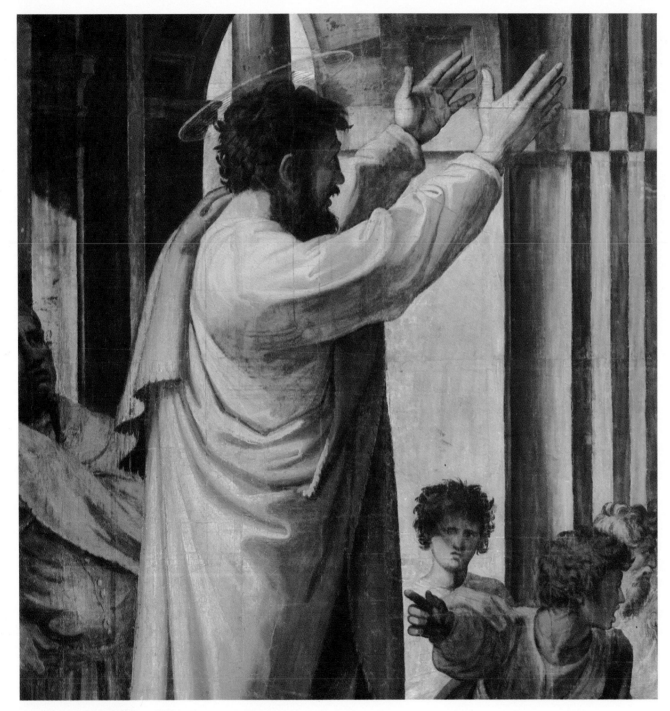

41. St Paul Preaching at Athens. Detail, St Paul

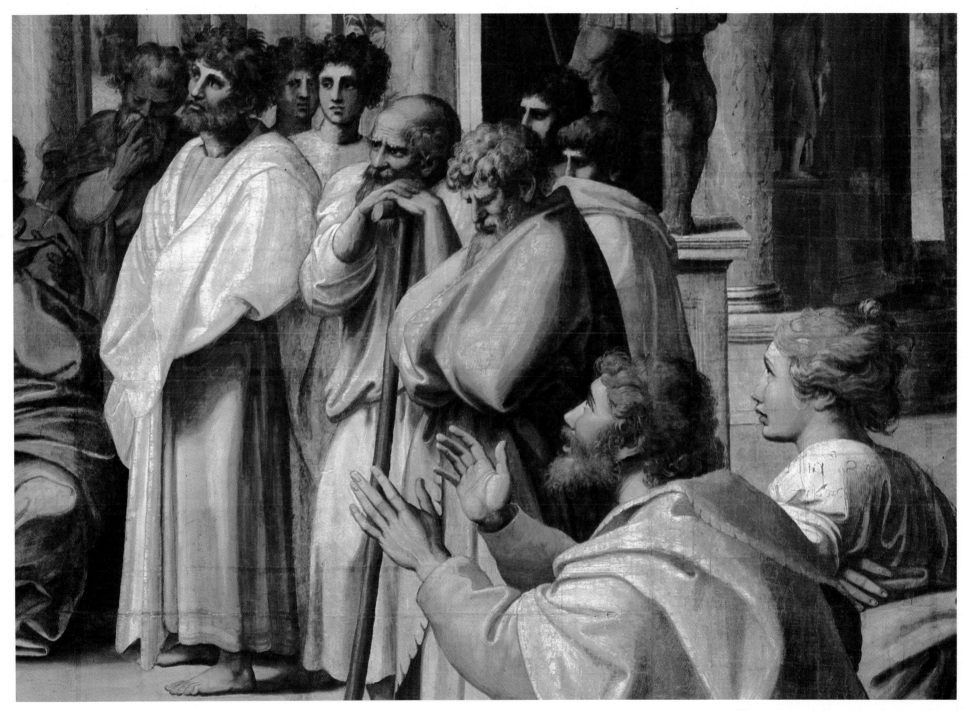

42. St Paul Preaching at Athens. Detail, the audience

Short bibliography

E. Müntz. *Les Tapisseries de Raphael au Vatican*. Paris, 1897

E. Kumsch. *Die Apostel-Geschichte*. Dresden, 1914

O. Fischel. *Raphael*. London, 1948

J. White and J. Shearman, 'Raphael's Tapestries and their Cartoons' in *Art Bulletin*, vol. xl, 1958, pp. 193–221, 299–323

S. Freedberg. *Painting of the High Renaissance in Rome and Florence*. Cambridge, Mass., 1961

J. Pope-Hennessy. *Raphael*. London, 1970

J. Shearman. *Raphael's Cartoons in the Royal Collection and the Leonine Tapestries in the Sistine Chapel*. London, 1972

P. Joannides. *The Drawings of Raphael*. Oxford, 1983

R. Jones and N. Penny. *Raphael*. Yale, 1983

Note. Those who have read the earlier version written by Sir John Pope-Hennessy (Large Picture Book No. 5, 1950; reissued as Colour Book No. 1, 1966) will appreciate how much the present book owes to it. J.W.

Sizes of the cartoons

The Miraculous Draught of Fishes *height* 10 ft 5$\frac{1}{2}$ in *width* 13 ft 1 in
Christ's Charge to St Peter *height* 11 ft 3$\frac{1}{4}$ in *width* 17 ft 5$\frac{3}{4}$ in
The Healing of the Lame Man *height* 11 ft 3 in *width* 17 ft 6$\frac{3}{4}$ in
The Death of Ananias *height* 11 ft 2$\frac{3}{4}$ in *width* 17 ft 5$\frac{1}{2}$ in
The Blinding of Elymas *height* 11 ft 2$\frac{3}{4}$ in *width* 14 ft 7$\frac{1}{2}$ in
The Sacrifice at Lystra *height* 11 ft 4$\frac{1}{2}$ in *width* 17 ft 9$\frac{1}{2}$ in
St Paul Preaching at Athens *height* 11 ft 3$\frac{1}{4}$ in *width* 14 ft 6 in

The colour plates are as large as possible, thereby altering the relative scales.